M000286442

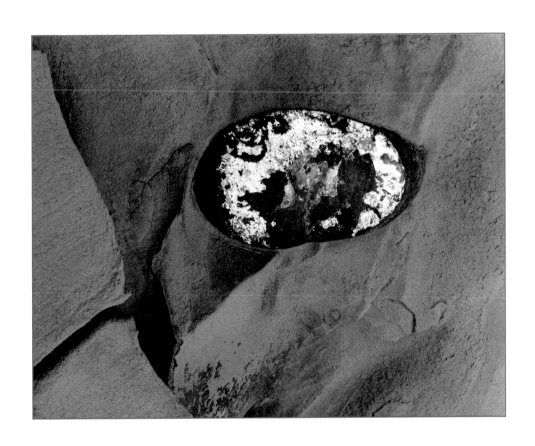

EYE
MIND
SPIRIT
THE ENDURING LEGACY OF
MINOR WHITE

EDITED BY NATHAN LYONS

HOWARD GREENBERG GALLERY

Published by the Howard Greenberg Gallery
in conjunction with the exhibition:
"Eye Mind Spirit: the Enduring Legacy of Minor White"
12 September–18 October 2008

ISBN: 978-0-9748863-0-5

Cover: 72 N. Union Street, Rochester, New York, 1958.
Frontispiece: Shore Acres, Oregon, 1959.

PREFACE

by PETER C. BUNNELL

MINOR WHITE WAS BORN A HUNDRED YEARS AGO THIS YEAR. Though he died in 1967, it is fitting that we commemorate his life in 2008. He has been seen as an enigma by some, and, he was much more than a photographic artist. He was a life-long teacher, a writer-critic, an editor, a curator of images, and something of a philosopher. A man of so many pursuits was richly complicated; fractured, but stable. At some points in his career he was more one figure than another. But for the whole of his life in photography, from the late 1930s until his death, he was always one to be reckoned with. He was a force in the medium at a time when, after the Second World War, everything was changing in the arts in ways that have brought us to where we are today. Had he not lived we cannot say the nature of the medium would be dramatically different than it is, but what is clear, is that he was integral to the changes both with regard to the look of its images as well as to the philosophical and stylistic underpinnings of late modernist photography. If we credit Alfred Stieglitz with setting American photography on a track for the early twentieth century, then we must see Minor White as an influential figure in the direction of the medium in the middle years of that century. That White encountered Stieglitz"s work and ideas before the war, and the man himself after it, solidifies this seamless generational heritage.

Born in Minneapolis in 1908, White began his photographic journey there as an amateur in about 1937. Importantly, he was at the time studying literature and writing poetry, and this later pursuit, especially through the 1940s, would be a model for his photographic endeavor. Before the war he moved to Portland, Oregon where he began his career in earnest and in every respect: image making, writing, teaching and art historical curating. After service in the war he briefly studies art history with Meyer Shapiro at Colombia University and befriended Beaumont and Nancy Newhall at the Museum of Modern Art.

Then, in 1946, it was on to the California School of Fine Arts in San Francisco where White developed close relationships with Ansel Adams and Edward Weston. In 1953 he located

to Rochester, New York and worked first at George Eastman House and then taught at the Rochester Institute of Technology. It was there I met and studied with him and came to know this unique, self-effacing and devout man. Here he put into full practice his considerable experience in the methodology of teaching and the study of meaning in photographs. By this time he was also editing and publishing *Aperture,* a journal of critical thinking about photography. Then too, in the late 1950s and early 1960s, he developed the workshop format of non-institutional teaching. In 1963 he moved outside Boston to found the program in photographic studies at MIT. In the eight years before his death, he merged all of the facets of his long career in an intensified and inspired form: curating three large thematic exhibitions and his second retrospective exhibition, and authoring the first monograph on his work, *Mirrors Messages Manifestations.* Through all the years he continued to make photographs, some years being more productive than others. His photographs are the touchstone for his ideas—the embodiment of his ideas and the testament to his ideas. There are many thousands of images. They carry with them a special beauty and spiritual power; they seem to arise from a mysterious impulse and from an enormous private and artistic need. The photographs, like certain poems, have the aura of a voice. White worked in a form called the equivalent—an image of metaphor and suggestion—that derives from Steiglitz's concepts and work. Importantly too, and again from Steiglitz, he early on adopted the sequence form of presentation that recognized that not all photographs need function as individual or summational works, but that certain pictures in a structured context could serve in support of others and could create a total statement more complex than single works alone. The literariness of this visual construct relates directly to the flourish of the poetic in his early training. In all he completed more than twenty sequences and they anchor his entire production.

The hallmark of a Minor White photograph is always apparent. It is rooted in a tension between what is depicted—the reality of the moment in light—and what the image might signify. One can understand this and recognize that such intent requires a special consciousness. In a 1964 précis for a proposed book to be titled, *Canons of Camerawork* White described his philosophy and his approach. He wrote:

> The aim of camerawork is the exploration of intensified consciousness. "camerawork" includes the knowledgeable use of the communicative, evocative, confrontative potentials of the medium. "Intensified consciousness" (or heightened awareness) refers to the consciousness of both the photographer and the audience. Put in another way this means that the "transaction" of photography includes awareness of subject, camera, photographer and audience by all four elements of the transaction. Stated still another way, the aim is practical mysticism.

He continued by stating the three canons: "Be still with yourself. Let the subject generate its own composition. When the photograph is a mirror of the man, and the man is a mirror of the world, then Spirit might take over. These are generative rather than specific, more like koans than directives."

Finally, he commented on the concept of the equivalent, which he says "[I] first encountered in reading *America and Alfred Steiglitz* in 1939 or 1940 and that it has been the basis of all my photography, and teaching, and much of the writing. The photograph as metaphor parallels the Taoist philosophy 'as in Heaven, so on earth' or in modern terms 'what we see is a mirror of ourselves.'"

And he concluded, "At present the working 'credo' is stated thus—camerawork used in my search for intensified consciousness, both for myself and for others." Today we recognize that Minor White bequeathed to us, with amazing generosity, a passionate belief in the power of spiritual aesthetics to shape our perception and our lives.

Peter C. Bunnell is Curator Emeritus of the Minor White Archive
at the Princeton University Art Museum

72 NORTH UNION STREET

by NATHAN LYONS

MY FIRST THOUGHTS WHEN I SAT DOWN TO WRITE THIS ESSAY, were of what I could add to the already extant literature on Minor: Peter Bunnell's, *Minor White: The Eye That Shapes;* James Baker Hall's, *Minor White: Rites and Passages* and, more recently, *The Moment of Seeing: Minor White at the California School of Fine Arts* by Stephanie Comer and Deborah Klochko with an essay by Jeff Gunderson. All these works contribute to creating a thoughtful portrait and history of the man, Minor White. What seemed immediately apparent to me was that I should rely on personal reminiscences and simply proceed by reconstructing what I could remember.

The street address above was, for a period of time, the home of Minor White in Rochester, New York. It was also the editorial office of *Aperture* magazine and a meeting place for a number of photographers who gathered on a regular basis to discuss and critique each other's work from the mid 1950s until the mid 1960s.

His apartment was situated above a hardware store that adjoined a relatively new roadway, called the Inner Loop, which provided easy access in and out of what was at the time a fairly vibrant downtown community. As urban planning often went, the roadway generated questionable results that contributed to isolating related areas of the city in a way that eventually required numerous revitalization projects in an attempt to restore some of the city's past glory.

Minor chose to live on the edge of this major divide that cut a swath through the city. He often discussed his disdain for the local landscape but, in spite of this, made some of his more memorable photographs in and around Rochester. However, he reserved most of his energies for photographing on his western trips during his summer breaks from RIT to teach workshops in Portland, San Francisco or Colorado. The summer always meant that I would receive a trail of postcards with brief descriptions of his journey's progress always ending with the salutation, "Cheerio, Minor."

If you faced the front of the hardware store you would readily notice that the building had gone through a series of alterations from what had been a rather large private home to its present function. A former entry with a porch was converted into a store front that now led to an amazing array of parts—hasps, fasteners, hinges, latches—contained in wooden boxes neatly shelved within long rows. The contents were identified by attaching a sample of each part to the front of each box, in effect a visual cataloging system. You name it, it was there. To the left of the entry to the hardware store was a door that led to a long narrow staircase up to Minor's apartment. At the top of the stairs you might find a pile of books that were there for the taking. I still have my copy of *The Wingless Pegasus: A Handbook for Critics* by George Boas. Other books that I acquired from this very spot have been dispersed to others through the years, mostly to students. A U-turn brought you to an entry toward the front of the building that led to a rather small room that housed the editorial office of *Aperture*. Passing through it you entered a larger room with a bay window to the left, the site for many of Minor's frosted window photographs. To the right was a wall, some eight to ten feet long, with a print rail that ran its length. Behind that wall was another room with print cabinets. A photograph of the kitchen, as viewed from this room, can be seen on page 11 in *Mirrors Message Manifestations.* The door on the left led to the attic and the door straight ahead led down to the darkroom. You can just see the edge of a table that was ingeniously designed to enable one to collapse it and move it very readily to the center room as a layout table or for a dinner. It was here, in this larger room, that we met on an average of once a week until Minor left Rochester for MIT in 1965.

This was the setting for many long evenings of reviewing work that often led to intense discussion and, yes, arguments; but I may be getting a little ahead of myself. It may be helpful to give you some sense of how I wound up in Rochester and of my association with the Rochester photo-scene. So let me share with you what were, in fact, a number of curious circumstances that led to what I thought would only be a temporary stop-over in Rochester in the fall of 1957.

After a four-year stint in the Air Force, I returned to Alfred University to complete my BFA degree in literature. One highlight of my return was the good fortune to be able to study photography with John Wood. He arrived in Alfred just about the same time I was discharged from the service in 1954. John was not teaching an official course in photography but he agreed to meet with me once a week, over a cup of coffee in the student union, to challenge the progression of my work. One of the most important issues that I had begun to explore were sequential concerns in relation to developing a body of work and its presentation. This represented an important connection for me with my study of poetry and subsequently provided me with, although I was unaware of it at the time, a "calling card" for my introduction to Minor.

Upon completion of my studies at Alfred, I asked John where I might continue. It was, in fact, his suggestion that I should talk with Aaron Siskind and Harry Callahan, Edward Steichen

and Minor. I visited MOMA, had a productive conversation with Steichen's assistant and then made a trip to visit Minor. It was during this visit that Minor invited me to become one of his private students. Minor had recently left the George Eastman House to teach full time at the Rochester Institute of Technology, work independently with a select group of students and continue to guide the editorial direction of *Aperture*. I arrived in Rochester in the fall of 1957 and stayed with a friend while I began to look for work. After a number of interviews I wound up at the Eastman Kodak Company's employment office. During that interview I happened to ask, "Is there any department at Kodak that is interested in what effect photographs have on people?" I can't describe the expression on his face, but it registered somewhere between astonishment and bewilderment, and thankfully he did say that I might want to call the George Eastman House because he had heard that they were looking for someone to work on their publication, *Image*. It was this coincidence that led me to the Eastman House and an interview with Beaumont Newhall the following week. I was hired to assume what had been Minor's editorial responsibilities on the museum's publication, *Image*, and to manage public relations for the museum. Walter Chappell had just been hired to take over Minor's curatorial responsibilities. Walter had arrived somewhat earlier with his wife and stayed in the attic space above Minor's apartment. He had known Minor since Portland and added a fairly dynamic energy to the mix of people that were beginning to assemble. It was Walter who introduced Minor to the *I Ching*, Zen, and the philosophy of Gurdgieff. As I recall, one of the first things Walter did when he arrived was to build a darkroom in Minor's basement that they both used for a time. He also began to do some challenging writing for *Aperture.*

I began to divide my time between studying with Minor and working at the George Eastman House. Weekends were reserved for photographing or, if it rained or snowed, I was off to the museum's library or its print collection, a truly marvelous and rare opportunity to steep myself in the history of the medium.

At the time, Minor was deeply interested in the issue of "reading" photographs. This concern had begun much earlier in 1952 stimulated, I believe, by a series of conversations and articles written by Henry Holmes Smith that resonated strongly with the work of the literary theorist I. A. Richards. Our discussions often centered on an attempt to verbalize the experience one derived from a given photograph or group of photographs. My prior experience dealing with the critical analysis of poetry made me very cautious and sensitive to the analytical strategies that were being applied in the workshop. After one evening session Minor asked me what I thought of the workshop. I hesitated for a moment and then said that I had some severe reservations about the direction it was taking. Then he hesitated for a moment and said, "All right then you teach the next workshop." I accepted the challenge. Minor and five of his private students became my first students. To his credit he consistently photographed in relation to the problems or exercises that

were posed each week. The attempt was essentially to explore a visual and less-verbal premise in the interpretation of images. I mention this primarily to illustrate his ability and willingness to switch roles from teacher to student. It is a lesson that I have carried with me through almost fifty years of my own teaching: to always retain the ability to become the "student."

After the workshop cycle ended, meetings at Minor's were devoted to work-in-progress rather than structured assignments or exercises and, as a result, the dominant quality of our discussions changed to incorporate the concerns of practitioners rather than those of students. In a given evening those in attendance might include Minor, Walter, Ralph Hattersley, Paul Caponigero (when he was in town), me and some of Minor's private students.

There was no telling what to expect on a visit to 72 North Union. Mounting the stairs on one occasion I could hear a lively discussion taking place between Minor and a voice I didn't recognize. The voice turned out to be Dorothy Norman's: the discussion, some problems with the layout of the *Aperture* issue she was doing on Alfred Steigletz. After things calmed down we had a marvelous conversation about Steigletz and his work. On another occasion Minor might want to discuss an editorial he was preparing or an article he was writing for a forthcoming issue. The discussions were challenging and often led to peeling back another layer of concern. There was inevitably, of course, the reading of another one of Minor's manuscripts. I was continually amazed by his ability to articulate a pedagogical position in an attempt to explain what he felt were the inner workings of a photographer in the act of making a photograph. None of the manuscripts were ever published and only a few carbon copies, I believe, currently exist. If published, they would represent an important contribution to the understanding of Minor's teachings.

Another significant issue that needs some discussion is the fact that the community of photographic interest at the time was extremely small, certainly by today's standards. Many photographers often wore two, sometimes three, hats. The lucky ones could work as photographers and have some time for, what they often called, their "personal work." For others it was a matter of doing something else to earn a living to make time to photograph. The support structure was minimal. The expectation of earning a living from the sale of one's photographs was the furthest thing from anyone's mind. At the time, the Museum of Modern Art preferred a donation of your work but if they bought a print it was for fifteen dollars. A few years later the purchase price rose to twenty-five dollars. Few institutions were purchasing work on a regular basis, and the number of commercial galleries in the country could be counted on one hand.

It was not hard to have contact with people working in the field. Many of the issues that concerned us were uniformly felt but active centers were few. I believe that prior to the sixties *Aperture* had about eight hundred subscribers. While the community was small it was certainly persistent and through the fifties laid the groundwork that supported developments in the sixties, which subsequently laid the groundwork for most of the major developments of the seventies. At

the center of most of this activity was a small group of highly dedicated individuals. There is no doubt that Minor was one of the forces that radiated this energy by directing it through *Aperture* as well as through his teaching to create a ripple effect that was relatively wide spread. A generosity of spirit at the time was the glue that motivated many of us to work toward an enrichment of the field's infrastructure. Because of the selfless efforts of just a few, the few it is interesting to note were for the most part the photographers themselves, the field began to emerge and develop. Minor filled a series of prominent roles in this development: teacher, editor, explicator, ambassador, translator, and of course curator and photographer. While we may all share different memories of him, his contribution to the field was enormous and should be recognized as such especially as we celebrate the hundredth anniversary of his birth.

Nathan Lyons is Director Emeritus of the Visual Studies Workshop

ACKNOWLEDGMENTS

by HOWARD GREENBERG

IN 1972, DURING MY SECOND YEAR OF MAKING PHOTOGRAPHS, I HAD the occasion to look carefully and read through *Mirrors, Messages, Manifestations,* the first comprehensive book on the work of Minor White. I sat on a couch at "Aperion Workshops" in Millerton, NY, a stone's throw from what was then the home of *Aperture,* which Minor had created in 1952. I became immersed in his world, a disciple like so many others. My comprehension of the potential of photography became altered, and I never looked at or thought about photographs in the same way again.

As a dealer and gallerist, Minor White's photographs have always held a special place for me. But it took his one hundredth birthday, plus a moment when I was able to gather together enough prints of good quality to finally present a proper exhibition.

Several people have been instrumental in this effort. First, I would like to thank Melissa Harris who has entrusted to me a fine collection of Minor White photographs and sequences, which had previously belonged to the second editor and publisher of *Aperture,* Michael Hoffman. Abe Frajndlich, who spent substantial time with Minor White at the end of his life, was inspirational and generous with his collection and energy. John Goodman kicked in most recently with his great enthusiasm for contacting many of Minor's students and eliciting their work and words which will round out the exhibition. I thank Joan Lyons for her most capable and willing design of this book and Nathan Anderson for his production work in the gallery.

I am deeply grateful for the cooperation and unique assistance provided by Peter Bunnell. Peter is the Curator Emeritus of the Minor White Archive at the Princeton University Art Museum and has authored his own, important works on Minor White. He is the ultimate expert and constant keeper of the Minor White flame.

And finally, this project would never have been completed without the steady, reliable, and brilliant Nathan Lyons. By agreeing to curate and make deadlines, Nathan gave me the confidence to bring this exhibition to fruition. Over the years, Nathan's counsel and wisdom have been invaluable and he has my heartfelt appreciation.

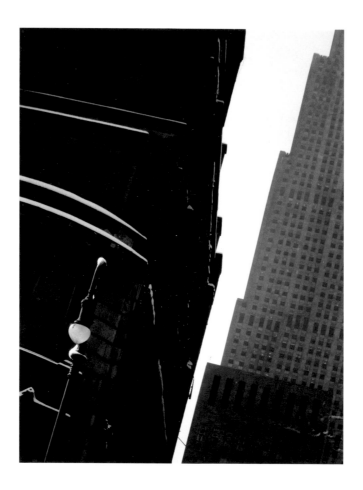

West 53rd Street, New York City, 1946.

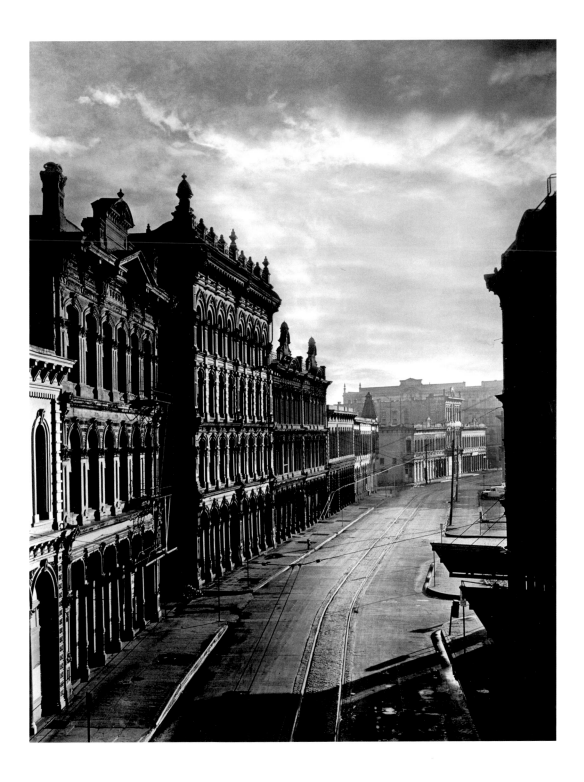

S.W. Front Avenue, Portland, Oregon, 1939.

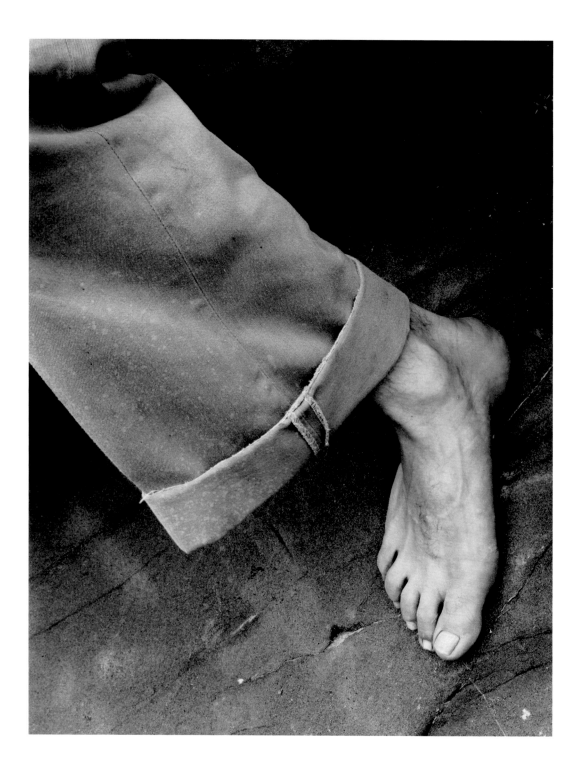

Tom Murphy, San Francisco, 1948.

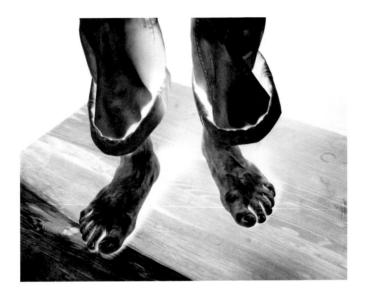

Tom Murphy, San Francisco, 1947.

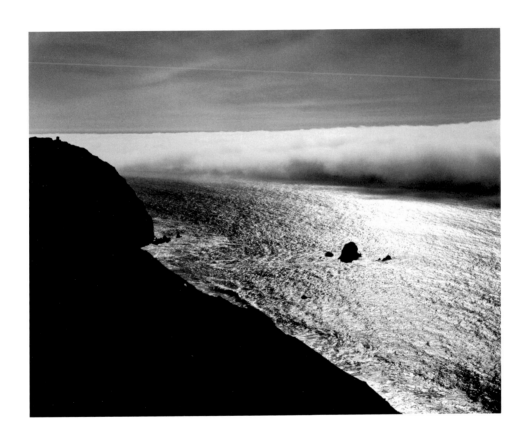

San Mateo County, California, 1947,
From the sequence "Song Without Words."

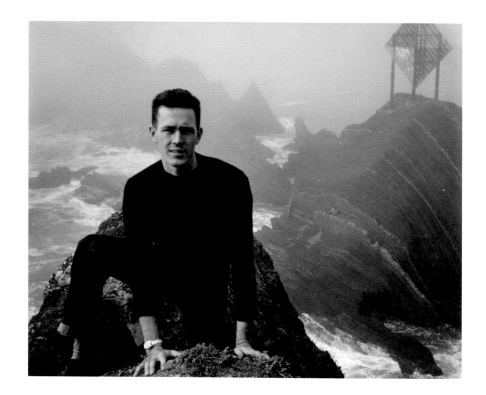

Bob Bright, San Pedro Point Marker, California, 1947,
From the sequence "Song Without Words."

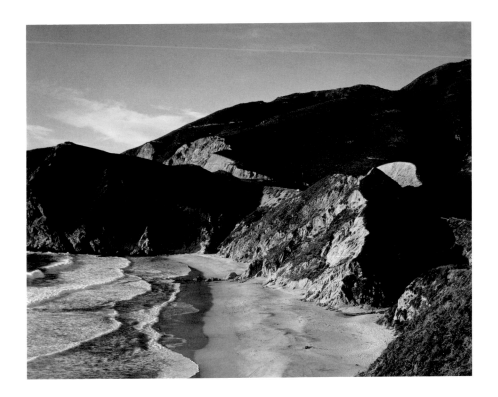

Matchstick Cove, San Mateo County, California, 1947,
From the sequence "Song Without Words."

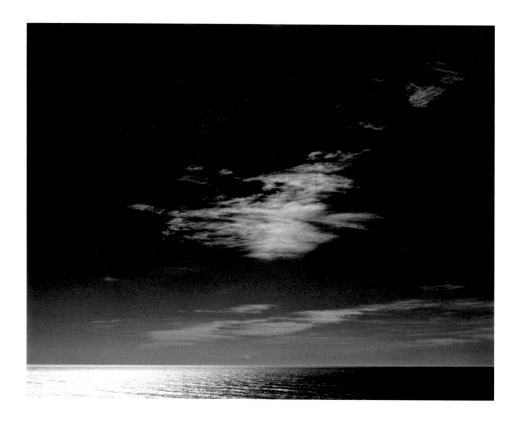

San Mateo County, California, 1947,
From the sequence "Song Without Words."

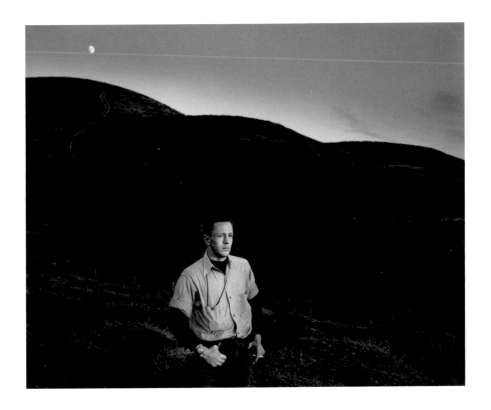

Tom Murphy, San Mateo County, California, 1947,
From the sequence "Song Without Words."

Columbus Avenue, San Francisco, 1949.

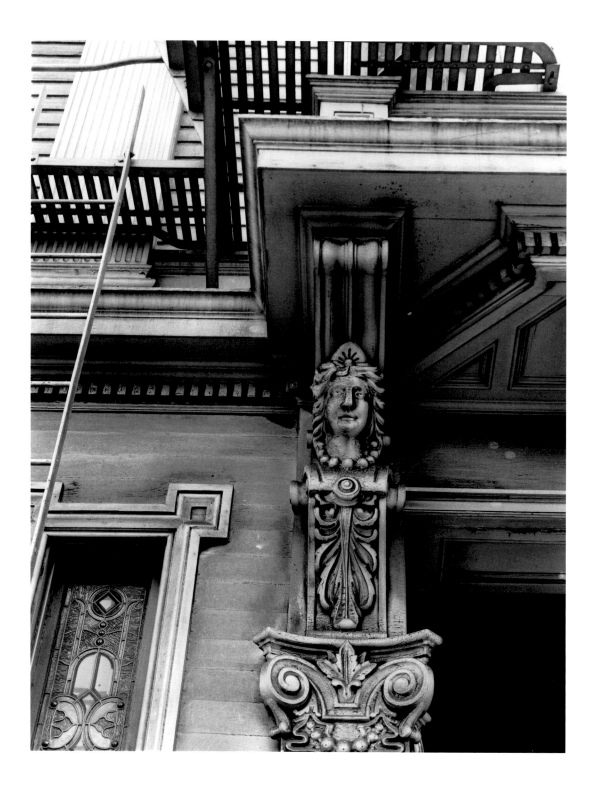

Buchanan Street, San Francisco, 1948.

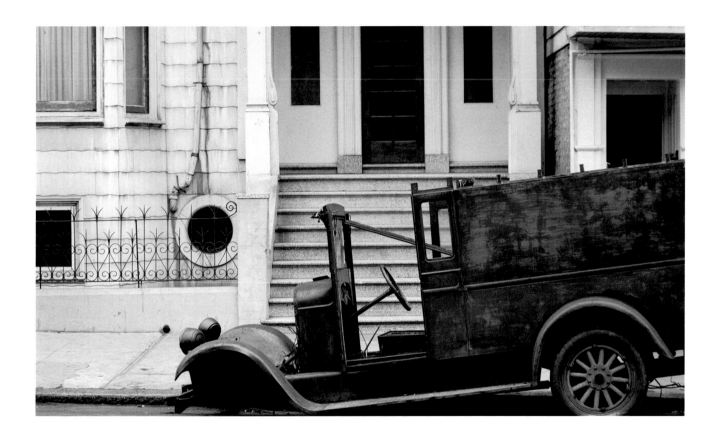

1412 Webster Street, San Francisco, 1948.

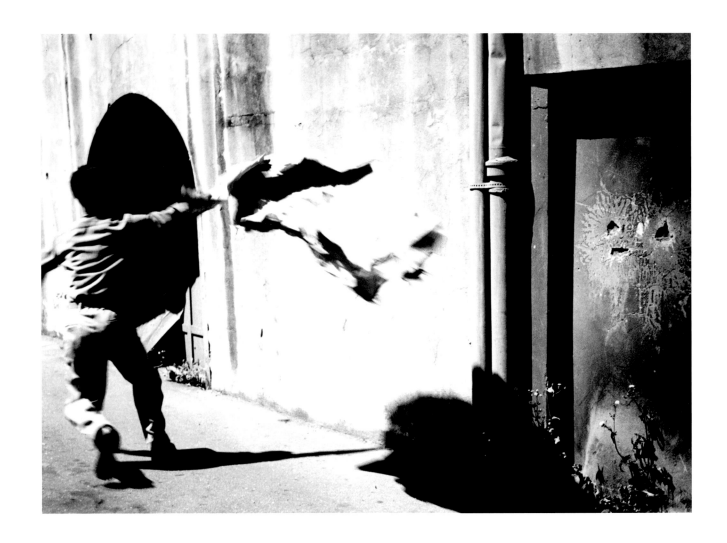

Warehouse Area, San Francisco, 1949.

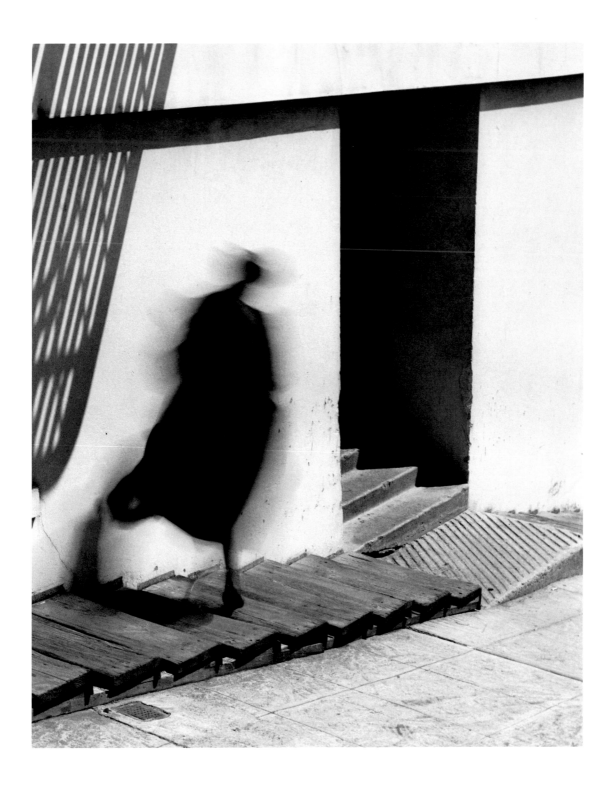

Movement Studies Number 56, San Francisco, 1949.

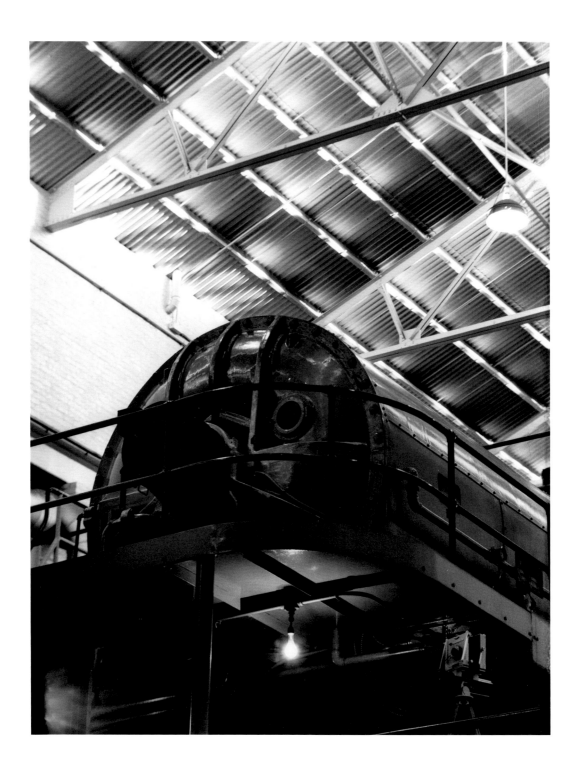

P.G.E. Station A, San Francisco, 1947.

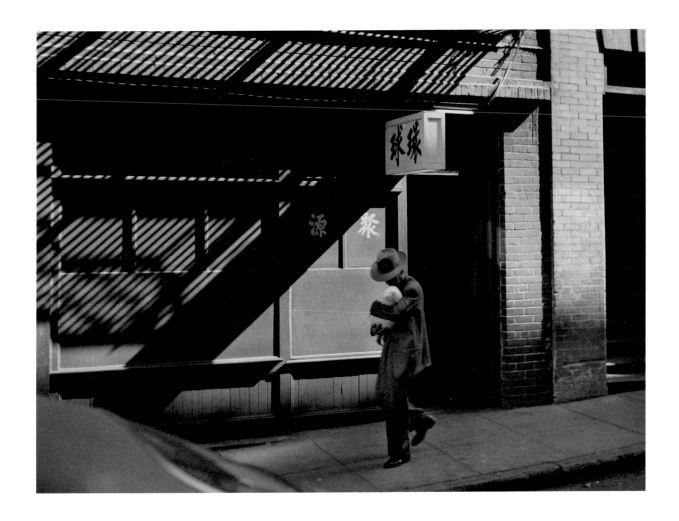

Chinatown, San Francisco, 1953.

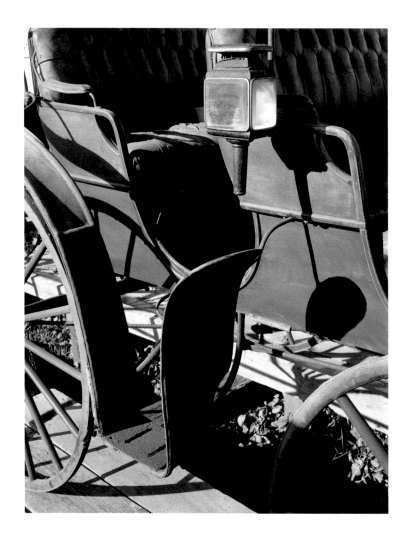

Mendocino, California, 1948.

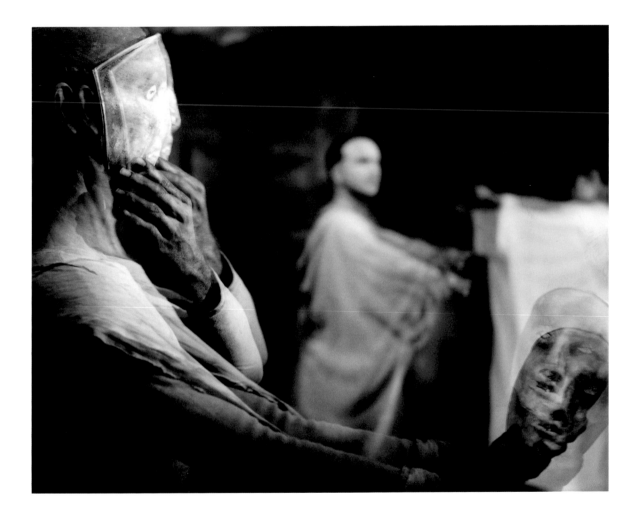

Interplayers Theater Group, "Dear Judas," San Francisco, 1953.

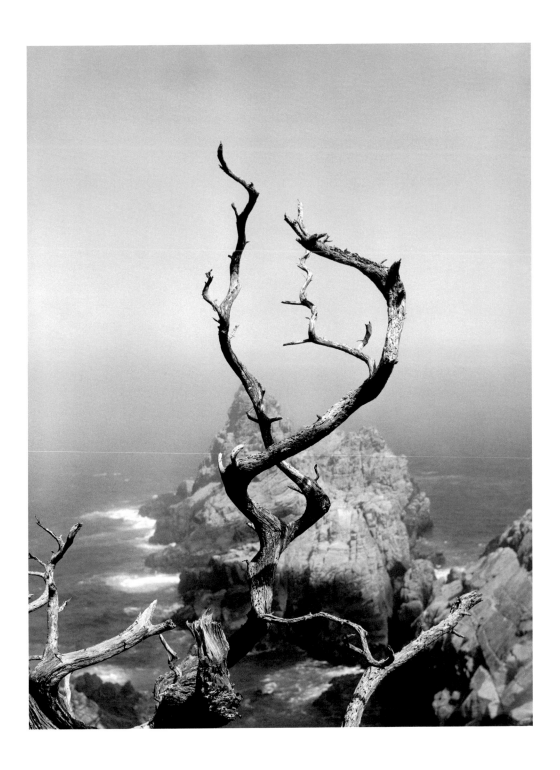

Cypress Grove Trail, Point Lobos, California, 1951.

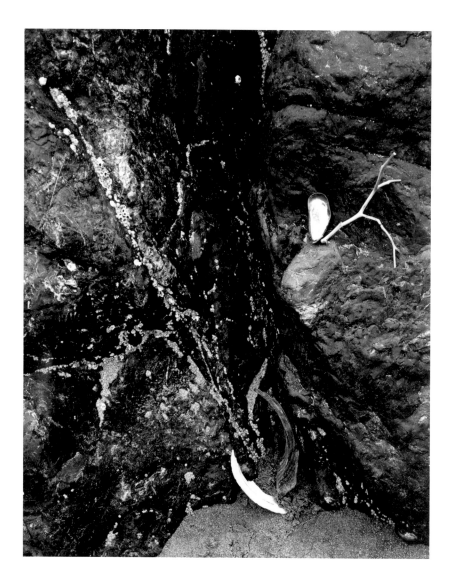

Point Lobos, California, Ca. 1948.

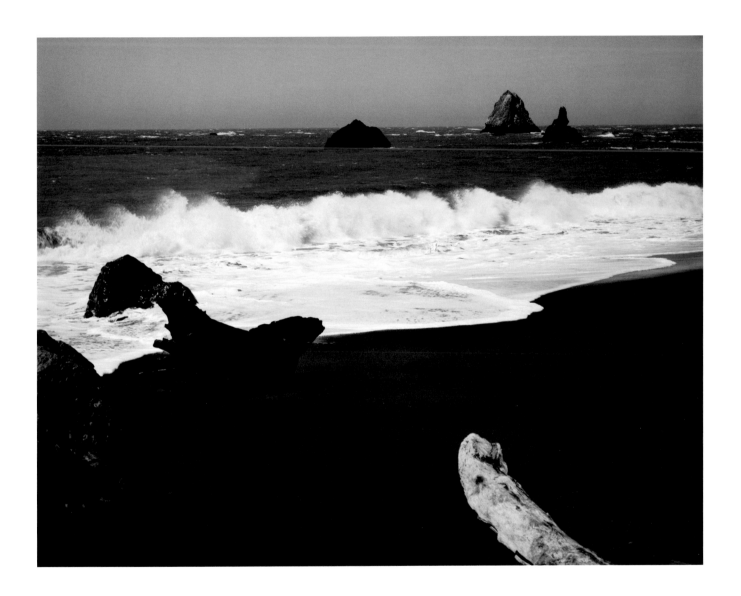

Mouth of the Russian River, California, 1949.

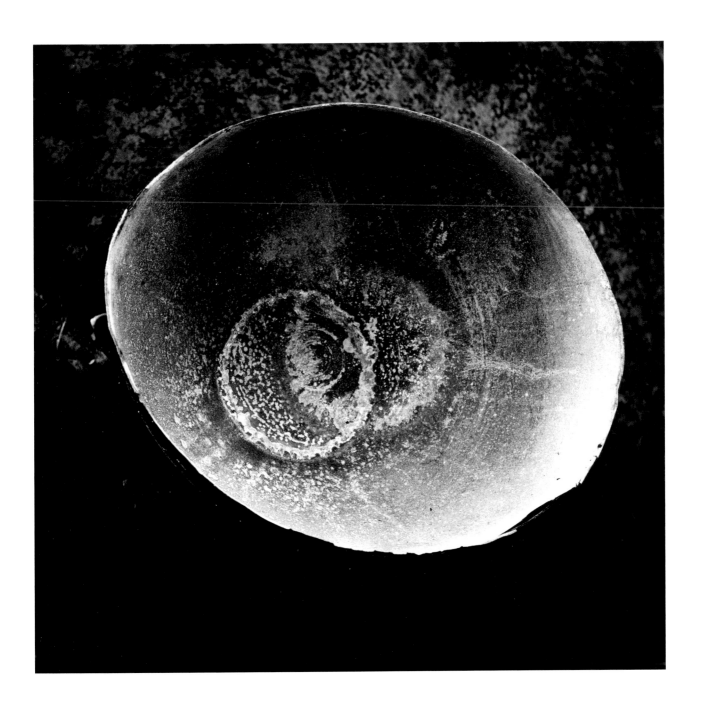

Pultneyville, New York, 1957,
From the sequence "The Sound of One Hand Clapping."

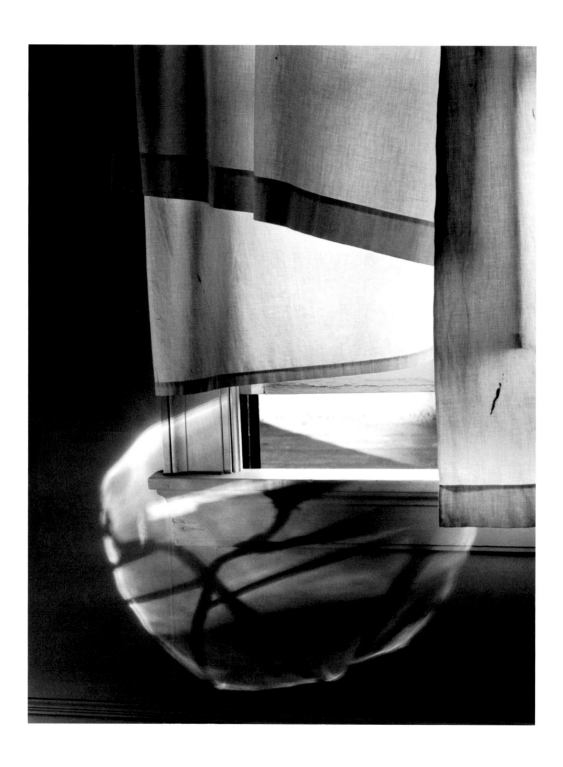

Windowsill Daydreaming, Rochester, New York, 1958,
From the sequence "The Sound of One Hand Clapping."

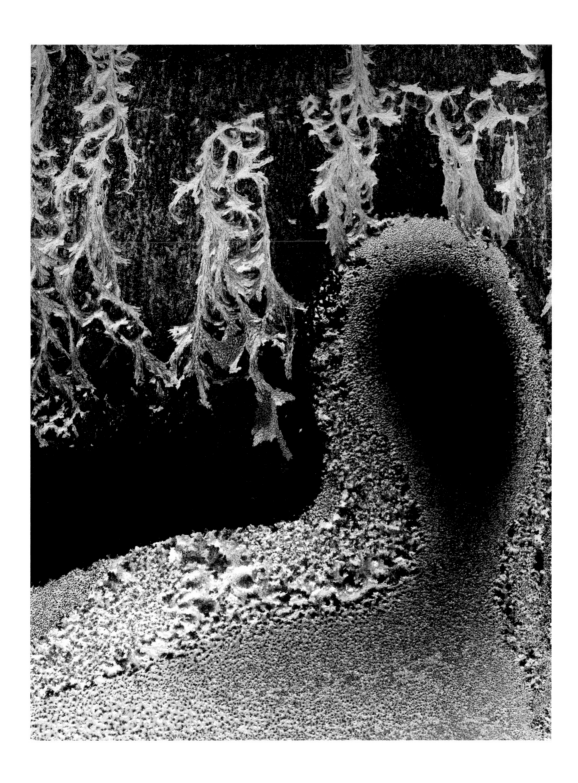

Empty Head, Rochester, New York, 1962,
From the sequence "The Sound of One Hand Clapping."

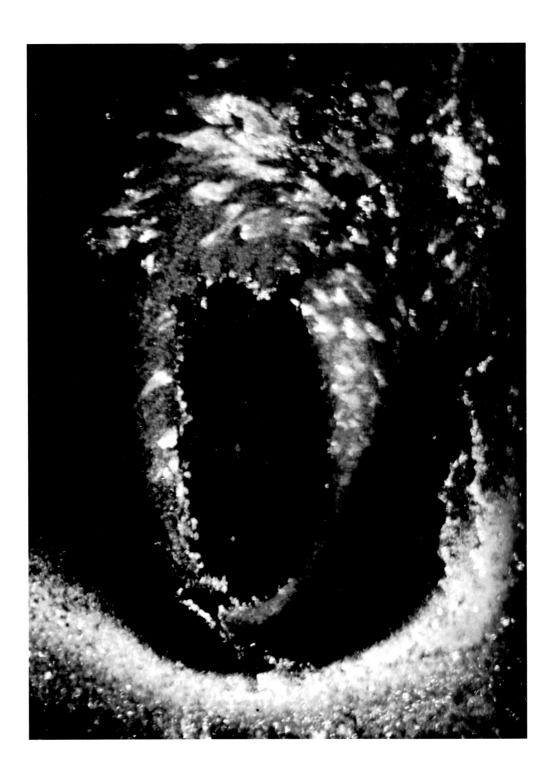

Rochester, New York, 1959,
From the sequence "The Sound of One Hand Clapping."

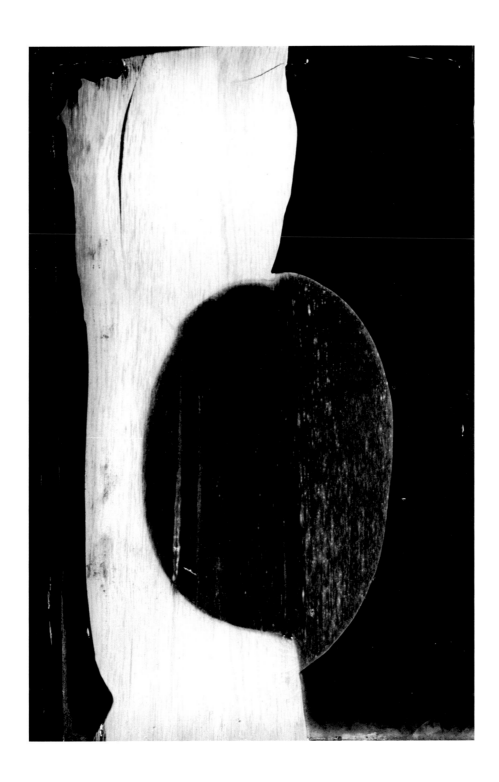

Rochester, New York, 1959,
From the sequence "The Sound of One Hand Clapping."

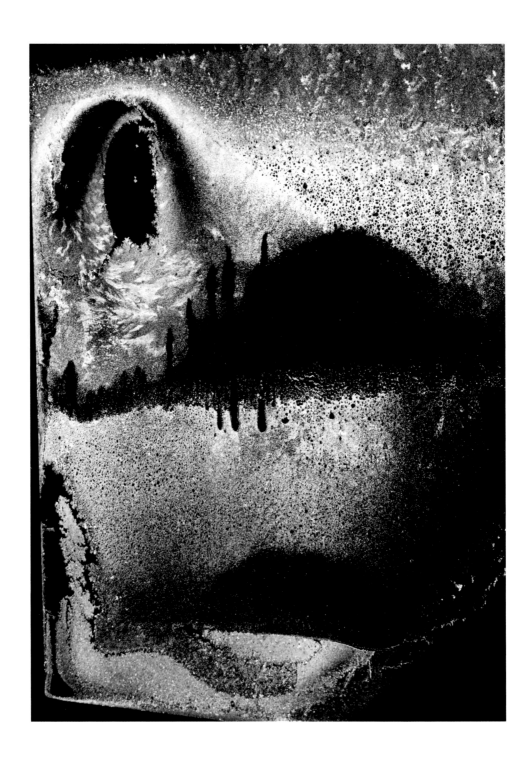

Dumb Face, Rochester, New York, 1959,
From the sequence "The Sound of One Hand Clapping."

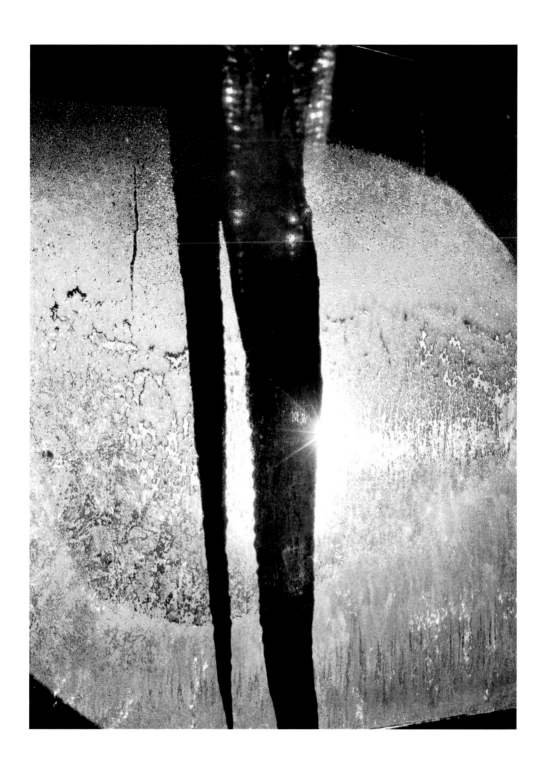

Night Icicle, Rochester, New York, 1959,
From the sequence "The Sound of One Hand Clapping."

48

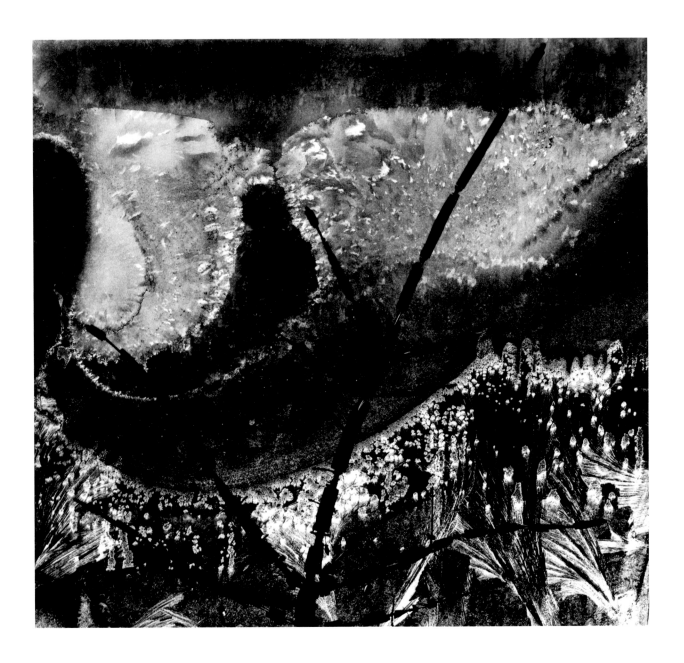

Ritual Branch, Rochester, New York, 1958,
From the sequence "The Sound of One Hand Clapping."

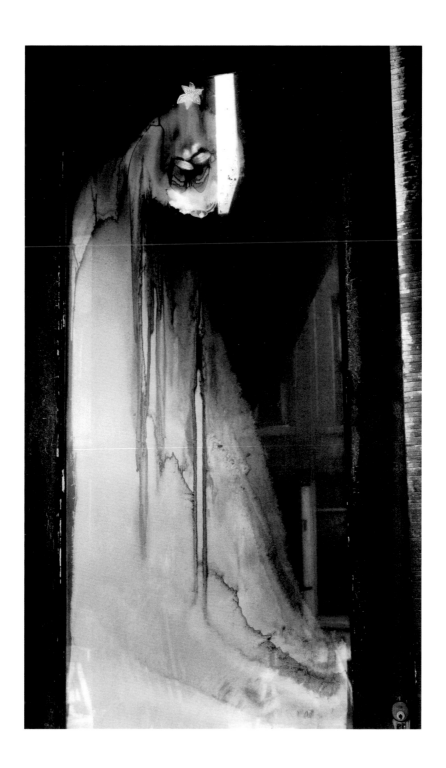

Batavia, New York, 1958,
From the sequence "The Sound of One Hand Clapping."

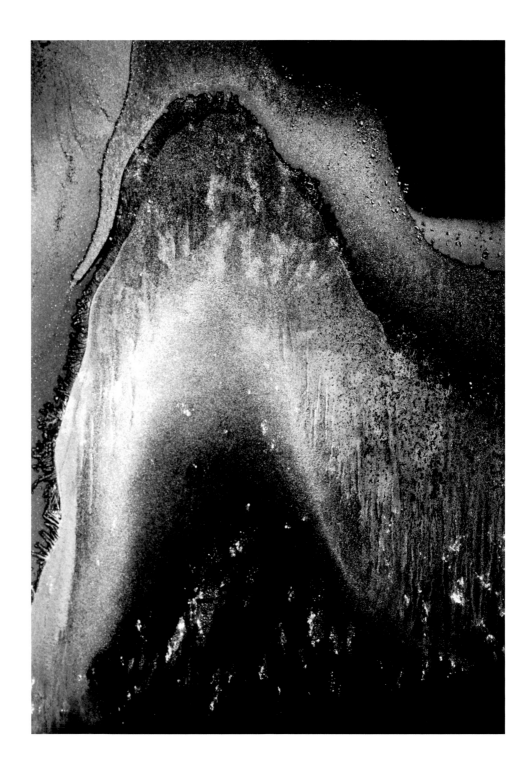

Rochester, New York, 1959,
From the sequence "The Sound of One Hand Clapping."

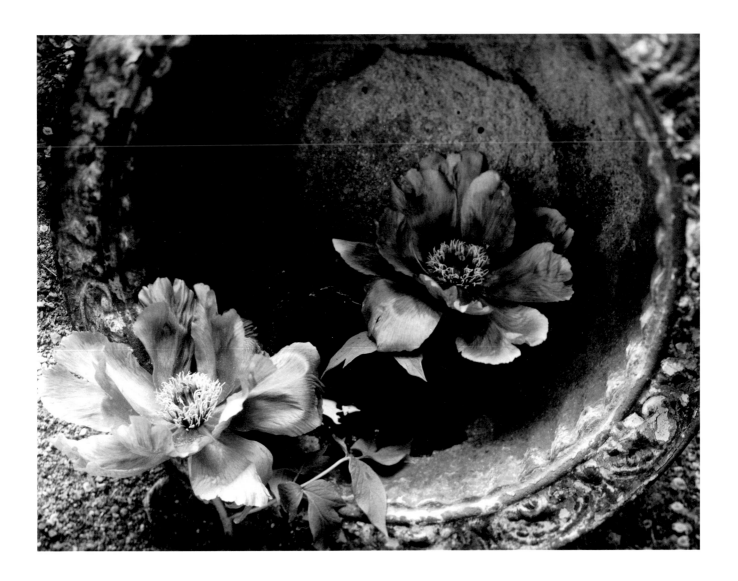

Pavilion, New York, 1957.

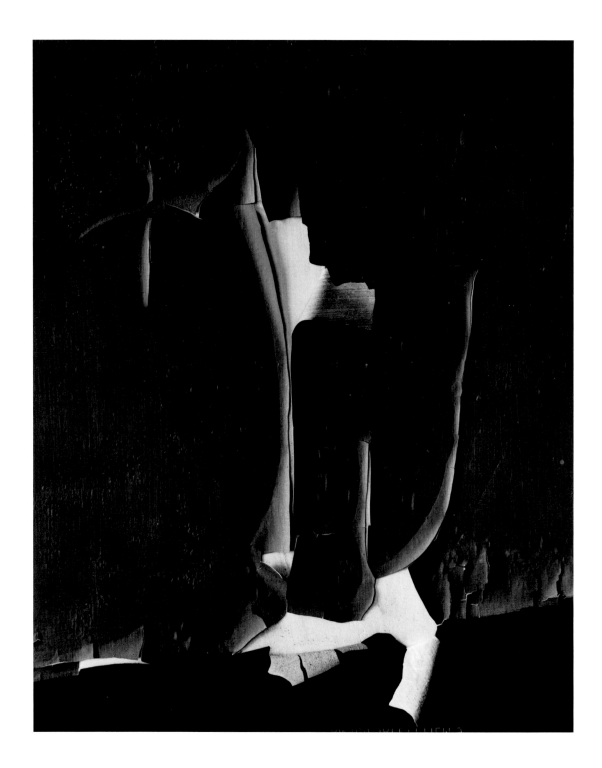

Rochester, New York, 1959.

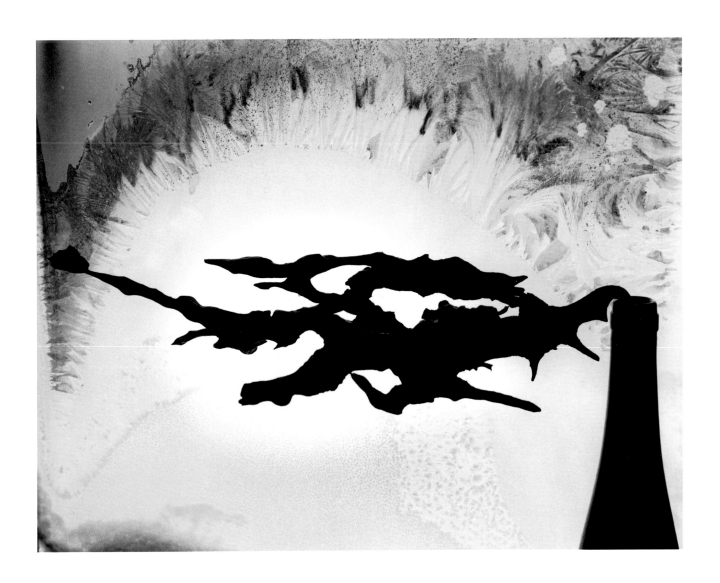

72 N. Union Street, Rochester, New York, 1958.

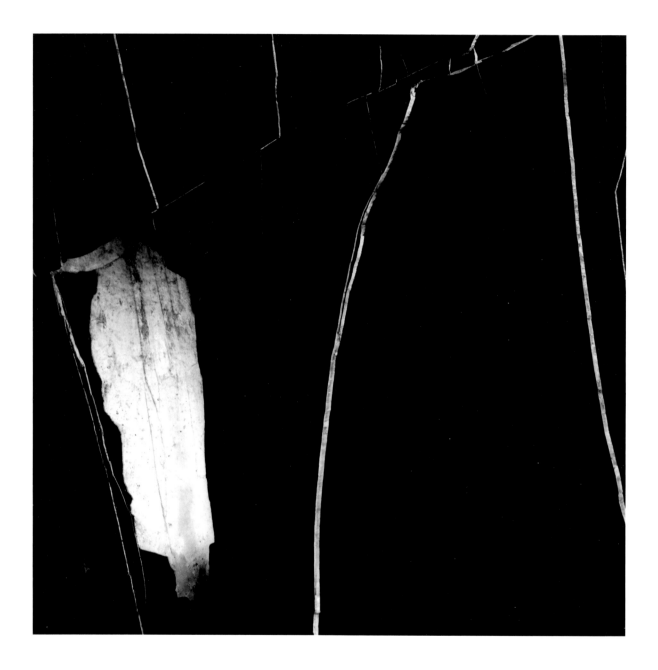

Capitol Reef, Utah, 1962.

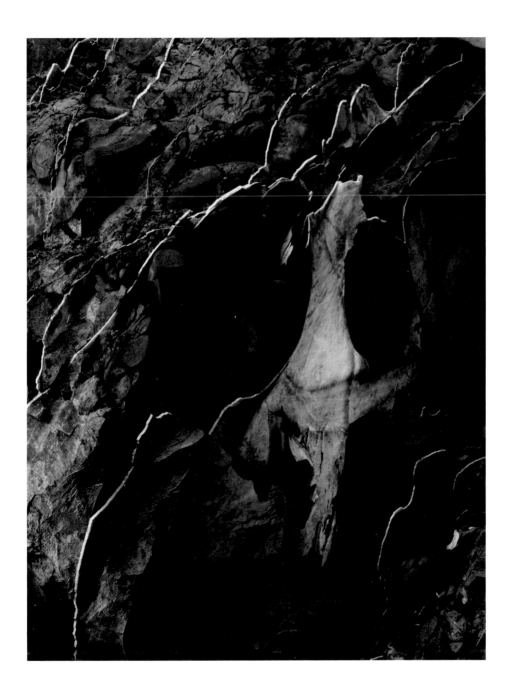

Capitol Reef, Utah, 1962.

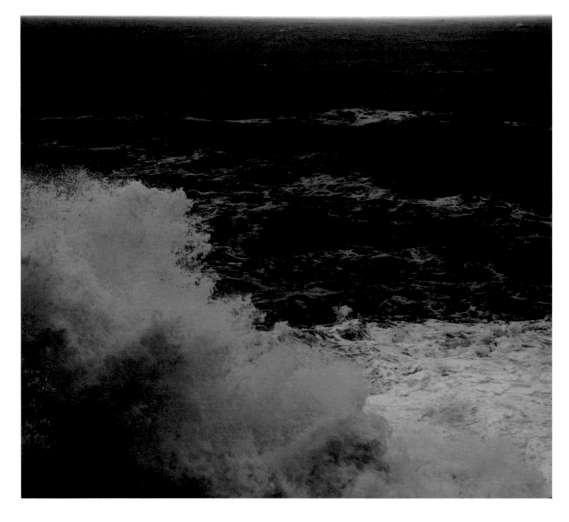

Shore Acres, Oregon, 1960.

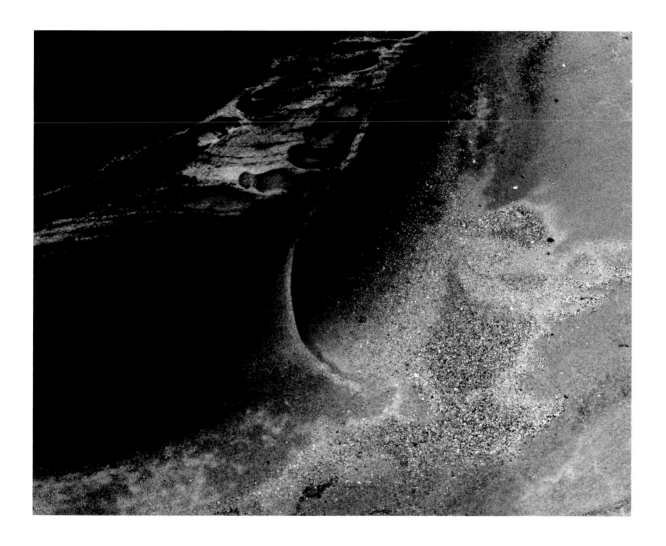

Shore Acres, Oregon, 1960.

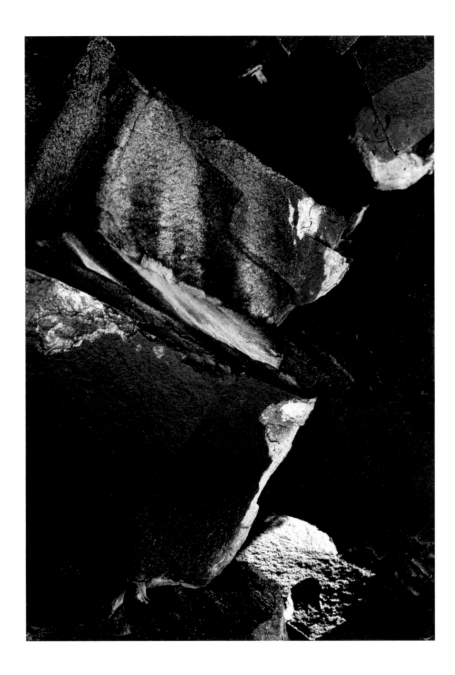

Henry Mountains, Utah, 1964.

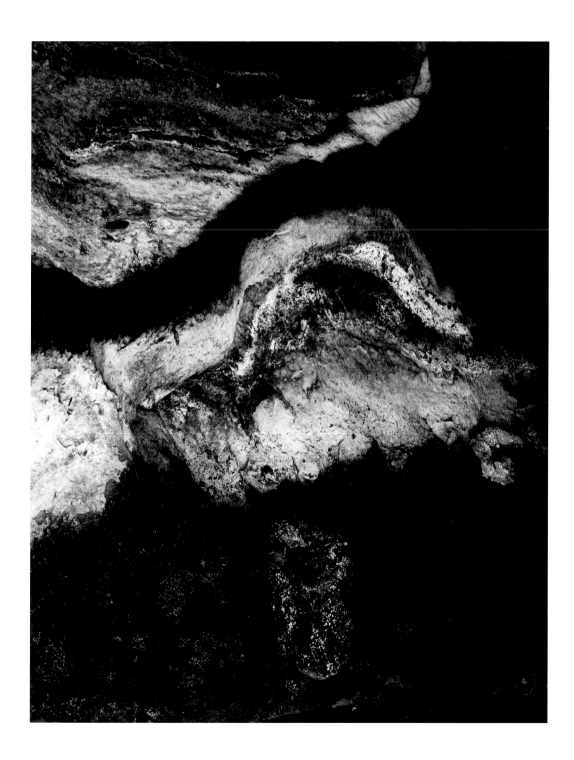

Capitol Reef, Utah, 1961.

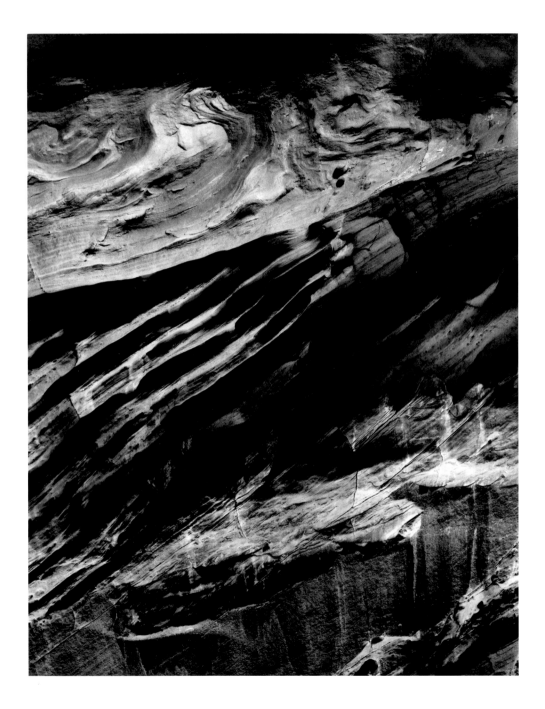

Capitol Reef, Utah (?), 1963.

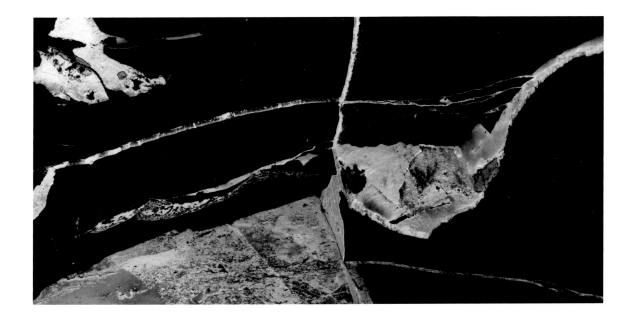

Capitol Reef, Utah, 1961.

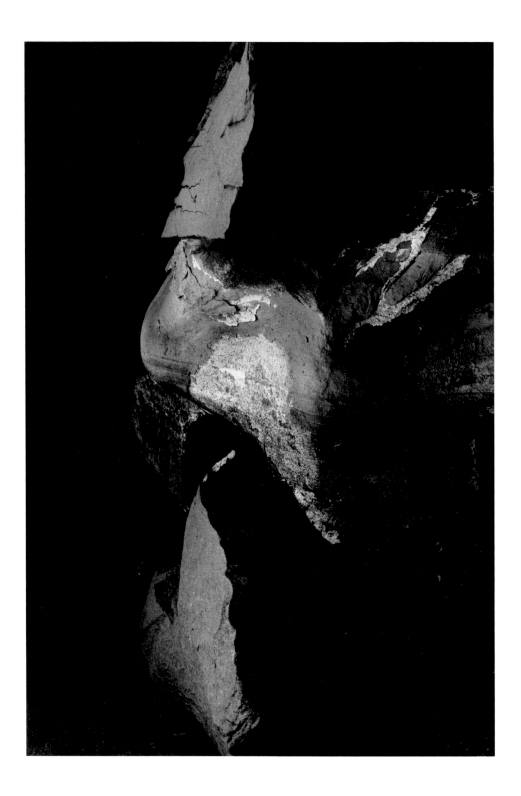

Utah (?), 1964.

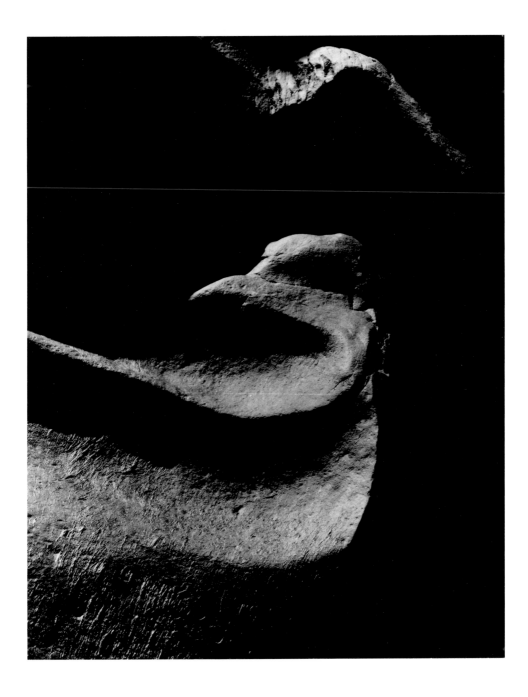

Sculptured Birds, Cape Mears, Oregon, 1964.

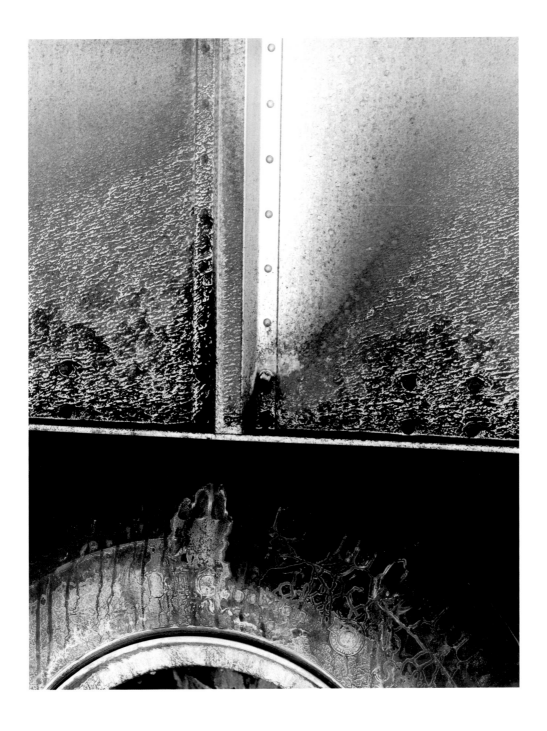

Portland, Maine, 1966.

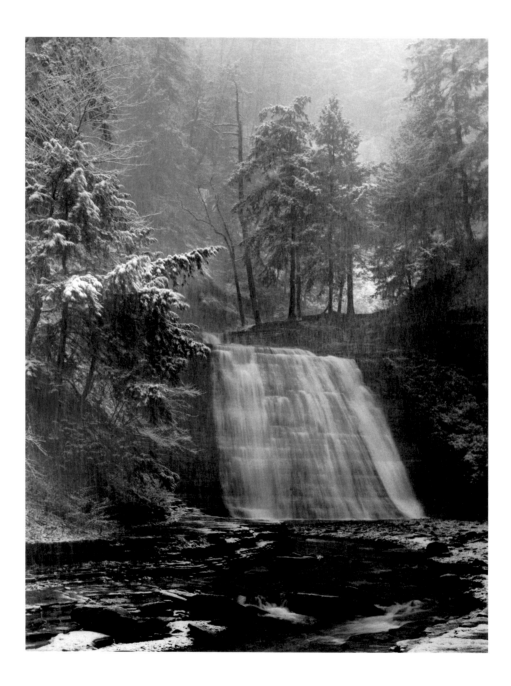

Stony Brook State Park, New York, 1959.

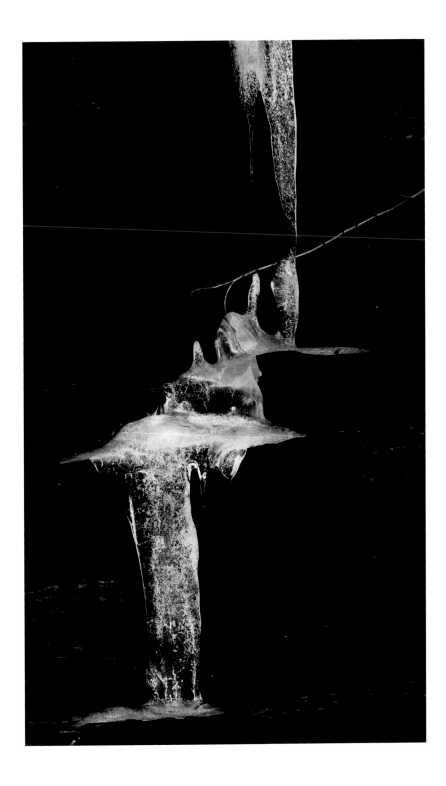

Watkins Glen, New York, 1963.

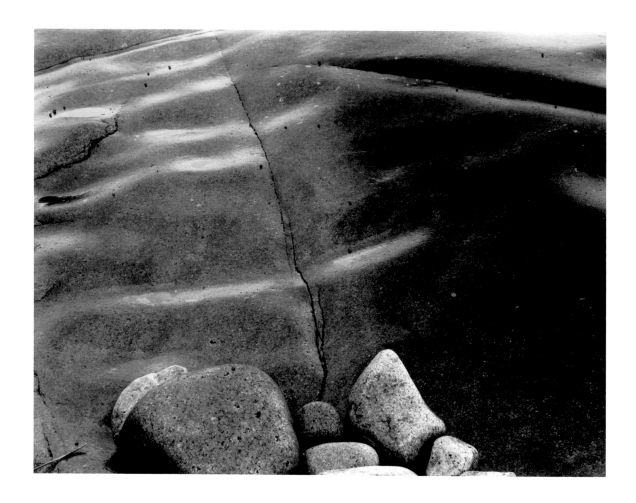

Schoodic Point, Maine, 1968.

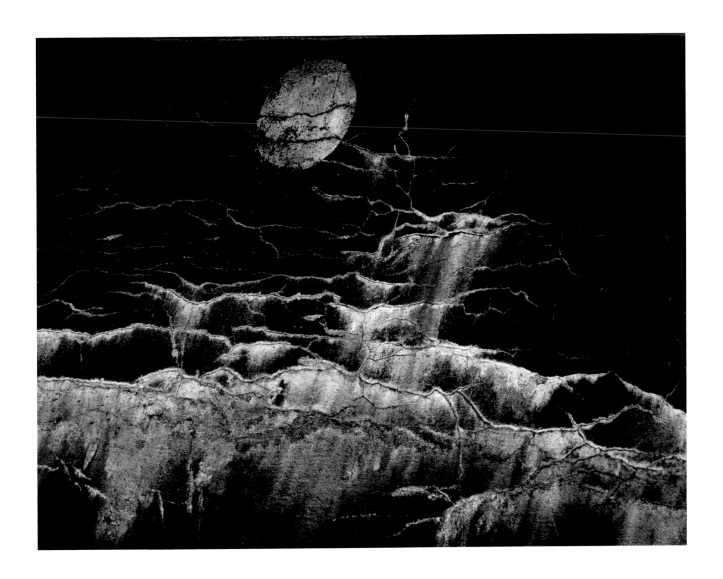

Moon and Wall Encrustation, Pultneyville, New York, 1964.

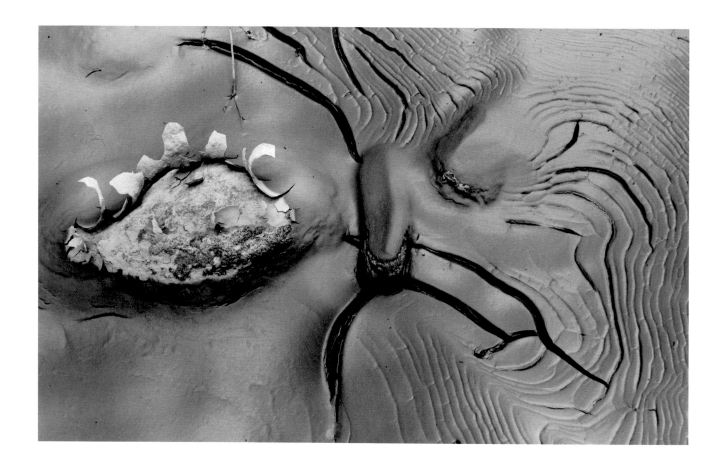

Capitol Reef, Utah, 1966.

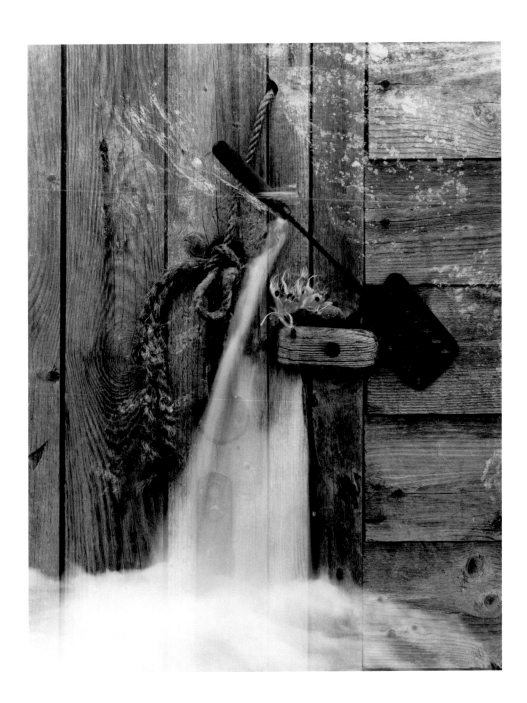

Vicinity of Lincoln, Vermont with Texas Falls, Vermont, 1970.

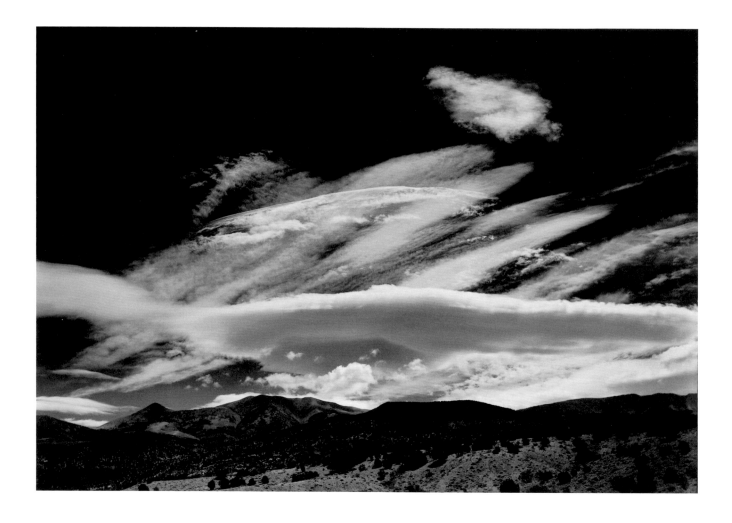

Henry Mountains, Utah, 1966.

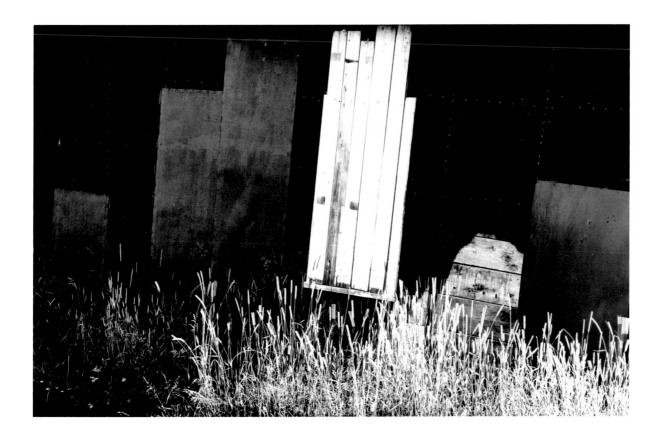

Lincoln, Vermont, 1968.

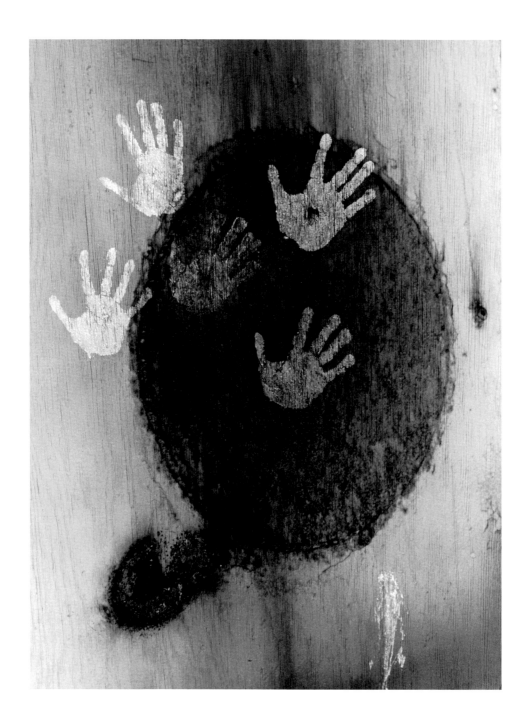

Gloucester, Massachusetts, 1973.

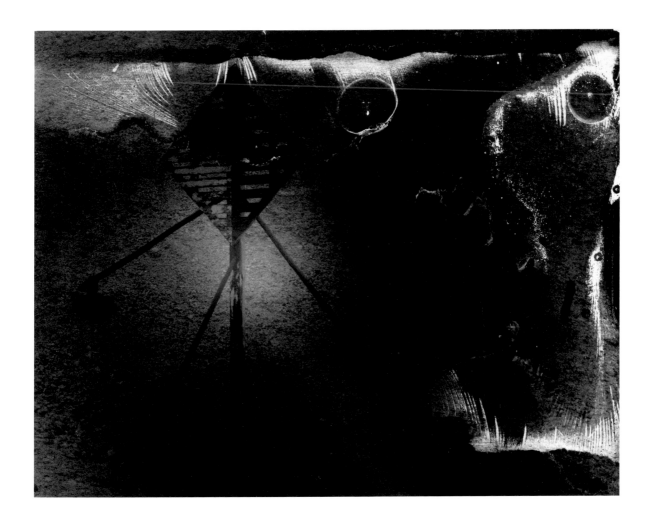

Cape Breton, Nova Scotia, 1970.

Howard Greenberg Gallery
41 East 57th Street, Suite 1406
New York, New York 10022
tel: 212.334.0010 fax: 212.941.7479
www.howardgreenberg.com

Project Director: Howard Greenberg
Project Coordinator: Nathan Anderson
Exhibition Curator: Nathan Lyons
Book Design by Joan Lyons
Digital photography and duotone separations by Thomas Palmer
Type composed in Simoncini Garamond and Baker Signet
Printed on 100# Job Parilux Silk Text by
Meridian Printing, East Greenwich, Rhode Island

This book is limited to 1,500 copies of which this is number **473**